ESSENTI

PHOTOGRAPHY

ESSENTIAL TIPS

101

PHOTOGRAPHY

Michael Langford

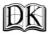

LONDON, NEW YORK, MELBOURNE,
MUNICH AND DELHI

Editor Damien Moore
Art Editor Ann Thompson
Managing Editor Gillian Roberts
Managing Art Editor Karen Sawyer
Category Publisher Mary-Clare Jerram
DTP Designer Sonia Charbonnier
Production Controller Luca Frassinetti

First published in Great Britain in 1996
This paperback edition published in Great Britain in 2003
by Dorling Kindersley Limited
80 Strand, London WC2R 0RL
Penguin Group (UK)

A CIP catalogue record for this book is available from The British Library

ISBN 1 4053 0344 1

Colour reproduced by Colourscan, Singapore
Printed by WKT, Hong Kong

discover more at
www.dk.com

ESSENTIAL TIPS

101

PAGES 8-14

CHOOSING EQUIPMENT

1Which camera is right for you?
2Simple compact cameras
3 ..The advantages of one-use cameras
4Advanced compact cameras
5 ..Basic SLR
6Advanced SLR
7The 35 mm film range
8Tripods & supports
9Camera bags
10Care & cleaning
11Choosing the right lens
12Flash facts
13Filter tips

PAGES 15-20

BASIC SKILLS

14 ...Loading your film automatically
15 ...How to load your film manually
16How to unload film correctly
17 ..Fogging
18Viewfinder tips
19Keeping the camera stable
20Extra support
21Avoid autofocusing pitfalls

PAGES 21-26

USING THE CONTROLS

22Manual focus
23Understanding shutter speeds
24Understanding aperture
25Achieving the right exposure
26When to bracket exposures
27Problems with exposure
28Manual exposure

PAGES 27-29

WHICH LENS?

29...........Understanding focal length
30................................Standard lens
31.............................Wide-angle lens
32......The advantages of using zoom
33....................................Long lenses

PAGES 30-31

CHOOSING FILM

34How to select the right film
35Colour negative
36...Slides
37Black & white negative
38How to look after your film

PAGES 32-37

COMPOSING YOUR PICTURE

39.........What makes a good picture?
40..............................Which format?
41Filling the frame
42............Where to place the subject
43....................Using the foreground
44.........Moving around your subject
45High or low viewpoint?
46Using frames within frames

47..............Emphasizing your subject
48Introducing a sense of scale
49How to use line

PAGES 38-39

USING COLOUR

50Colour for emphasis
51..............................A sense of space
52.............................Colour & mood

PAGES 40-41

PATTERN & SHAPE

53Symmetry
54Breaking the rhythm
55Using shadow
56 ...Shape
57Natural pattern
58 ..Texture

PAGES 42-45

USING NATURAL LIGHT

59 ...Light at various times of the day
60Hard & soft lighting
61How to advance the sunset
62How to make the sun move
63Shoot against the light
64How to avoid flare
65..................................Lighting casts

PAGES 46-47

USING FLASH

66Avoiding red eye
67Flash fall-off
68Using fill-in flash
69Bounced flash
70Angled flash

PAGES 48 56

PHOTOGRAPHING PEOPLE

71Avoid squinting
72Avoid clutter
73How to put your subject at ease
74Finding the best angle
75 ...Avoid creating false attachments
76 People wearing glasses
77 ...Using the right lens for portraits
78Natural fill-in
79 ..Informal pictures of children
80Special occasions
81Shooting pairs
82Self-portraits
83Group shots

PAGES 57-67

SPECIAL SUBJECTS

84Photographing your pets
85 ..Wildlife
86Landscapes
87Horizon tilt tip
88How to photograph panoramas
89 ..Buildings
90 ..Interiors
91Dramatic skylines
92Night-time photography
93Using reflection
94Action shots
95 How to capture the right moment
96 ...Still life
97Close-up shots

PAGES 68-69

PRESENTING PRINTS

98 ...Albums
99Cropping prints
100Framing your prints
101Other presentation methods

INDEX 70
ACKNOWLEDGMENTS 72

CHOOSING EQUIPMENT

1 WHICH CAMERA IS RIGHT FOR YOU?

Your choice of camera should depend upon your ambition as a photographer as well as upon your budget. Although advanced cameras are far more versatile than the basic models, they often have such a wide variety of functions that learning to use them can be a daunting task.

- Compact cameras are usually fully automatic, making them easy to use.
- SLR cameras have a manual override system for greater creativity.
- Compact cameras are smaller and lighter than most SLR models.
- SLR cameras can be used with an enormous range of accessories.

2 SIMPLE COMPACT CAMERAS

A basic point-and-shoot camera is a good, inexpensive choice for those who are not interested in the technical side of photography.

- The camera's lens is fixed to view subjects at a slightly wide angle.
- Exposure and focusing are fully automatic, limiting creativity.

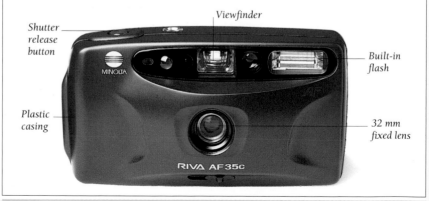

Viewfinder

Shutter release button

Built-in flash

Plastic casing

32 mm fixed lens

RIVA AF35c

3 THE ADVANTAGES OF ONE-USE CAMERAS

For parties, or other occasions where you might feel uneasy about taking your camera along, one-use cameras are a wise option. The whole camera costs only a little more than a standard roll of film.

- Some one-use cameras are even equipped with a built-in flash unit.
- Film is already fitted, so there are no loading and unloading delays.
- Waterproof one-use cameras are available – ideal for beach holidays.

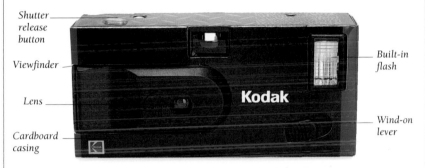

Shutter release button

Viewfinder

Lens

Cardboard casing

Built-in flash

Wind-on lever

4 ADVANCED COMPACT CAMERAS

This type of camera is ideal for the photographer who, although not necessarily technically minded, is keen to have some creative control over composition and framing.

- The focal length of the fixed zoom lens can range from wide angle to telephoto for flexibility in framing.
- Advanced compacts usually offer a range of exposure modes.

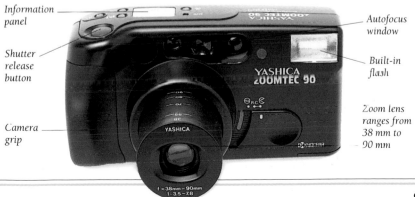

Information panel

Shutter release button

Camera grip

Autofocus window

Built-in flash

Zoom lens ranges from 38 mm to 90 mm

5 BASIC SLR

For the technically minded, keen to make photography a major pastime, the basic SLR is a good camera to start with. For about the same price as a decent compact, this camera offers all of the creative scope provided by a fully manual system. The SLR's through-the-lens metering shows the settings needed for correct exposure, but you can override the meter should you wish. Film must be loaded manually and wound on between frames.

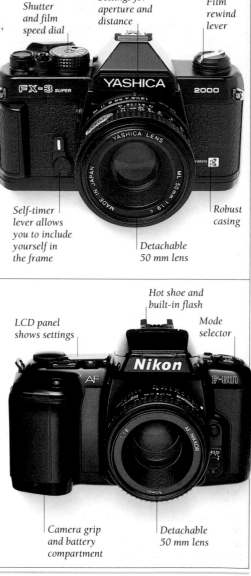

Shutter and film speed dial

Settings for aperture and distance

Film rewind lever

Self-timer lever allows you to include yourself in the frame

Detachable 50 mm lens

Robust casing

6 ADVANCED SLR

An advanced SLR is the 35 mm camera to which the real enthusiast should aspire. However, their high cost and complexity are discouraging for many people. With the convenience of automatic film transport, autofocus, and autoexposure, and the option of complete manual override, the advanced SLR camera offers the best of both worlds. Many models include such useful extras as built-in flash and motordrive (a system that exposes several frames per second).

LCD panel shows settings

Hot shoe and built-in flash

Mode selector

Camera grip and battery compartment

Detachable 50 mm lens

7 THE 35 MM FILM RANGE

Familiarize yourself with all the various types of film available in the 35 mm format before you decide on the brand you prefer. Colour negative film is the most popular and, consequently, the most readily available film on the market, but you may find that you prefer the ambience of black-and-white film, or the rich, bright colours produced on slide film. Each type of film has its own advantages and drawbacks.

△ NEGATIVE

COLOUR NEGATIVES
This type of film is popular because it produces good quality, low-cost colour prints that can be viewed instantly. Negatives show reversed tones and colours and so are hard to assess.

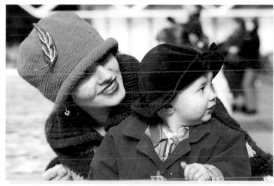
△ PRINT

△ PRINT
NEGATIVE ▷

◁ SLIDE

BLACK-AND-WHITE NEGATIVE
Although it is possible to produce black-and-white prints from colour negatives and slides, the best quality prints are produced from black-and-white negatives. As with colour film, the tones appear reversed on the negative.

COLOUR SLIDE
Colour slide film produces rich, true-to-life colours but must be projected in a darkened room to be viewed properly.

8 TRIPODS & SUPPORTS

Whatever camera you use, a tripod (or an alternative support, such as a monopod or clamp) is always a useful addition to your photographic equipment. A tripod allows you to use long exposure times, which may be necessary in dim light or when using a slow film. Size, sturdiness, versatility, and portability are the main considerations to take into account when choosing a tripod.

TRIPOD WITH LEGS FOLDED

TRIPOD WITH LEGS EXTENDED

9 CAMERA BAGS

Choose from an extensive range of weatherproof bags especially designed to protect your camera and accessories. Many bags have padded compartments that can be adjusted to suit your needs.

Pouches for spare film

Lenses and flash

Spare batteries are essential

CANVAS BAG

INTERIOR OF HOLDALL

The side panel is useful for smaller items such as filters

10 CARE & CLEANING

Use a blower brush to clear dust from the lens, and a soft, lint-free cloth to wipe away fingerprints. Cleaning fluid can be applied sparingly for more stubborn marks on the lens. A pair of tweezers might be useful if a hair should find its way into the camera back, but take great care to avoid contact with any high-precision component such as the camera's shutter. Prevention is better than cure, so where possible use a UV filter to protect the lens element.

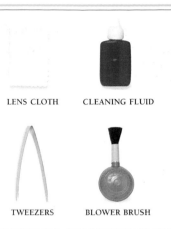

LENS CLOTH CLEANING FLUID

TWEEZERS BLOWER BRUSH

11 CHOOSING THE RIGHT LENS

Some lenses are better than others for certain subjects, so choose your lens according to the type of subject you wish to shoot. Additional lenses provide increased versatility.

- 50 mm is the "normal" or standard lens for a 35 mm camera system.
- Lenses with shorter focal lengths are known as wide-angle lenses; long lenses magnify the subject.

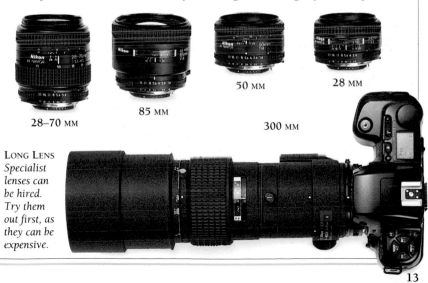

28–70 MM

85 MM

50 MM

28 MM

300 MM

LONG LENS *Specialist lenses can be hired. Try them out first, as they can be expensive.*

12 FLASH FACTS

Built-in flash systems need to be fairly small and so are not very effective for large subjects or long distances. It is worth investing in a more powerful flash unit if your camera is able to accommodate it.

- Choose a "dedicated" flash unit, which takes information from the camera's sensors to produce the correct exposure automatically.
- A flash unit with a movable head can be used to bounce the flash off a wall or ceiling for a softer effect.
- Autozoom flash units vary their coverage to match the lens used.
- With some units, the flash can be fired at reduced power if required.

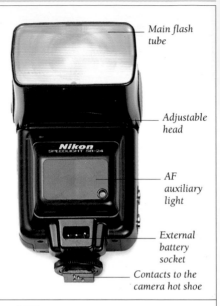

Main flash tube

Adjustable head

AF auxiliary light

External battery socket

Contacts to the camera hot shoe

POLARIZER

UV FILTER

DAYLIGHT FILTER

13 FILTER TIPS

Choose a selection of filters (lens attachments that alter the quality or colour of an image) to produce some simple but frequently dramatic special effects. Colour filter systems can be used to vary tones of black-and-white film, or to produce interesting casts on colour film.

- Although circular, screw-on filters are often the best, they can work out to be expensive because lens diameters vary.
- A system with a single filter holder may be less expensive.
- A UV filter can be left permanently attached to the lens to protect it from dirt.

BASIC SKILLS

14 LOADING YOUR FILM AUTOMATICALLY

Some cameras offer highly sophisticated film transport systems that load film automatically when the back of the camera is closed.

- Open the camera back in the shade.
- Place the cassette in the left-hand slot and pull the film leader across.
- Close the camera to start loading.

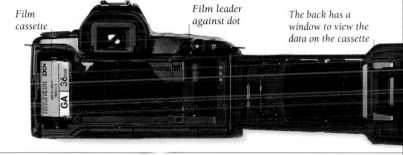

Film cassette

Film leader against dot

The back has a window to view the data on the cassette

15 HOW TO LOAD YOUR FILM MANUALLY

Raise the rewind crank and pull it up to allow access to the film chamber. Put the film in its chamber and push the rewind crank down.

- The film leader must be securely attached to the take-up spool.
- Close the camera back and wind on manually to the first frame.

Rewind crank

The film leader is engaged with the take-up spool

When loading film, the back should be opened in the shade

Film cassette

15

16 HOW TO UNLOAD FILM CORRECTLY

Unload a manual camera by pressing the release stud (usually positioned on the camera base) while turning the rewind crank in the direction indicated by an arrow symbol. The crank will suddenly turn loosely when the entire film is disengaged from the take-up spool. It is now safe to open the camera back to retrieve the film. With the rewind knob raised, simply tip the cassette into the palm of your hand.

■ Always find a shaded area before you open the back of the camera.
■ If you should open the back of the camera and find you have forgotten to rewind the film, close it straight away and rewind. Some of the last frames will be ruined but many of the others may be salvaged.
■ Many modern cameras rewind the film automatically when the final frame is reached and then indicate that the film is ready to be removed.

17 FOGGING

This common problem occurs when film is accidentally exposed to non-image-forming light. Opening the camera back before the film has been rewound is the most common mistake resulting in fogged images. However, light can seep onto a film even though it has been correctly rewound if it is not then stored in its original light-tight container. To help avoid fogging, put an exposed film in its container straight away and process it as soon as possible afterwards.

Light-tight container

Film cassette

PRINT RUINED BY FOGGING
Fogging usually appears on a print as a misty orange veil over the intended image.

18 VIEWFINDER TIPS

If you are using a compact camera, be sure to compose your subject within the framing lines indicated in the viewfinder or you will crop off part of your picture. A similar problem can occur with any camera if you do not place your eye close enough to the eyepiece.

- Because of "parallax" (*see below*), framing errors are greatest when you are shooting close to your subject.
- Some advanced compact cameras automatically compensate for parallax problems – shifting the viewfinder framing boundaries according to the subject's distance from the lens.
- If in doubt, include more of the surroundings than you need in your composition and then enlarge your intended main subject later on.

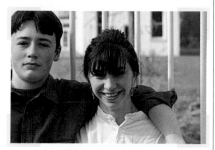

CROPPED CLOSE-UP

CORRECTLY FRAMED CLOSE-UP

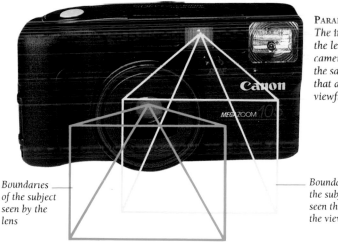

PARALLAX PROBLEM
The image seen by the lens of a compact camera is not exactly the same as the image that appears in the viewfinder.

Boundaries
of the subject
seen by the
lens

Boundaries of
the subject
seen through
the viewfinder

19 KEEPING THE CAMERA STABLE

If you wish to avoid blurred images (a problem known as camera shake) it is essential to keep your camera steady. Blur-free photographs can be taken with a hand-held camera at shutter speeds of $\frac{1}{60}$ provided that you hold the camera properly, the lens is not too long and heavy, and the subject is stationary. As the focal length of a lens increases, so must the shutter speed. For example, a 125 mm lens should not be used at shutter speeds of less than $\frac{1}{125}$.

△ CAMERA SHAKE
This problem is caused by holding your camera at slow shutter speeds.

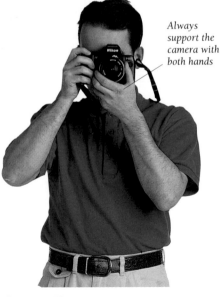

Always support the camera with both hands

STANDING UP
Keep the strap around your neck at all times; tuck your elbows in for stability.

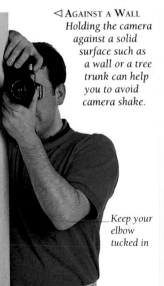

◁ AGAINST A WALL
Holding the camera against a solid surface such as a wall or a tree trunk can help you to avoid camera shake.

Keep your elbow tucked in

Keep your elbows away from the table edge

Keep your fingers away from the lens element

Firm canvas bag

ELBOWS ON THE TABLE
A table or a similar horizontal surface, such as a bench, can provide a handy support that will help to keep your camera steady.

TAKE IT LYING DOWN
A camera bag can make a useful support for low-viewpoint photographs. Make sure flaps and buckles do not obstruct the lens.

20 EXTRA SUPPORT

A tripod or similar device will become essential at shutter speeds below 1/60. However, your efforts will be wasted if you jolt the camera when you press the shutter release, so use a cable release if possible. (Alternatively, use a self-timer button if your camera has one, the camera should have steadied by the time the shutter fires.) Although tripods are the most versatile supports, allowing unlimited exposure times, a monopod or a clamp may be preferable if space is limited.

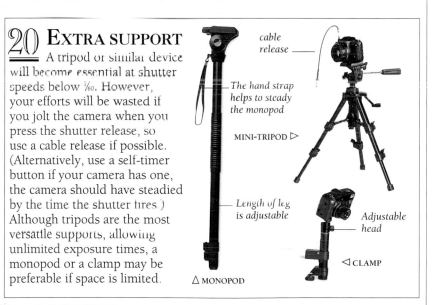

cable release

The hand strap helps to steady the monopod

MINI-TRIPOD ▷

Length of leg is adjustable

Adjustable head

◁ CLAMP

△ MONOPOD

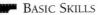
21 AVOID AUTOFOCUSING PITFALLS

Autofocus systems are highly advantageous, in that they allow you to concentrate on framing your shot. However, there is always the danger that the unit may read the wrong part of the scene, with the result that your intended main subject may appear on the final print as a blurred image.

SUBJECTS BLURRED ▷
In this picture, the centrally biased focusing system has read the wrong part of the scene. The foliage between the two main subjects is in sharp focus, whereas the subjects themselves appear as blurred images. Most autofocus systems read from the centre of the image.

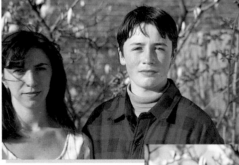

◁ AUTOFOCUS LOCK
Good quality autofocusing systems usually provide an autofocus lock option. Here, the camera was moved to place one of the subjects in the centre of the frame in order to lock the focus onto the correct distance.

CORRECT FOCUS ▷
When the autofocus has been locked to the right distance, you can re-frame the shot to include your subjects as they appeared in the original composition. This time, the two main subjects appear in sharp focus. It is the foliage in the background that now looks blurred, helping to emphasize the figures.

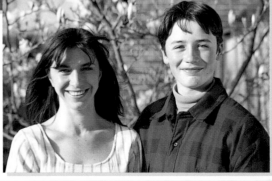

USING THE CONTROLS

22 MANUAL FOCUS

Some advanced compacts and all SLR cameras have adjustable focusing that allows you to decide which elements in a scene you wish to be sharply focused and which you want to remain blurred. Fixed focus lenses are set to record as much as possible of a scene in sharp focus – from about 2 m (6 ft) to infinity.

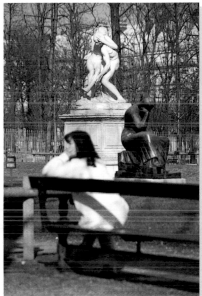

FOCUS ON THE BACKGROUND △
In this picture, our attention is drawn to the statues in the background. The image of the woman in the foreground is suppressed.

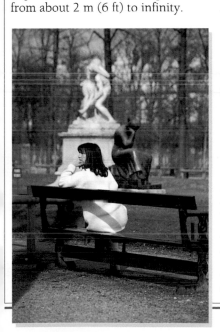

◁ FOREGROUND IN FOCUS
By turning the focus ring on the camera lens the woman in the foreground can be brought into sharp focus and the statues behind her are no longer the dominant feature.

23 UNDERSTANDING SHUTTER SPEEDS

Select a fast shutter speed to freeze moving subjects. To heighten a photograph's sense of movement and drama, select slow shutter speeds that make moving subjects appear as dynamic, blurred images on film.

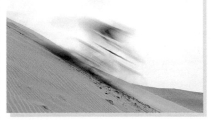

△ SLOW SHUTTER (⅛ SECOND)
Here, the shutter speed is too slow to capture any detail of the fast-moving cyclist.

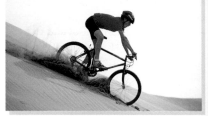

△ FAST SHUTTER (1/500 SECOND)
A fast shutter speed freezes the action. The spray of sand keeps the sense of movement.

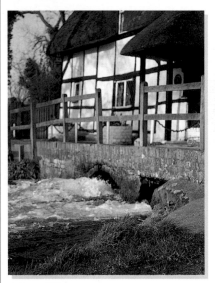

△ STILL WATERS
A fast shutter speed has been used to freeze the movement of the water under the bridge.

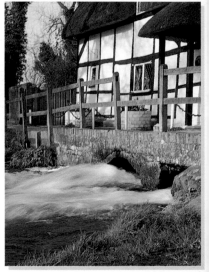

△ BLURRED EFFECT
Here, a slow shutter speed separates still and moving elements, blurring the water.

24 UNDERSTANDING APERTURE

Use the aperture to dictate the amount of light reaching the film and control image brightness. The size of the aperture also affects the amount of the scene that will be recorded in sharp focus. The zone of sharpness extending both in front of and behind the part of the subject you focused on is known as the "depth of field".

- The size of the aperture is indicated by f-numbers (also called f-stops).
- The larger the f-number, the smaller the lens aperture.
- The smaller the aperture setting, the deeper the depth of field.
- Use a wide aperture setting to soften distracting background detail, or to pick out a single face in a crowd.

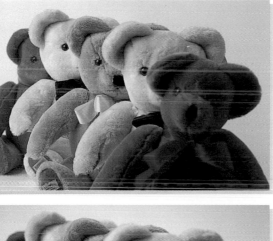

◁ **WIDE DEPTH**
Using a small aperture of f16 brings all of the teddy bears into acceptably sharp focus. The camera is focused on the middle teddy bear.

SMALL APERTURE

◁ **SHALLOW DEPTH**
With the camera focused on the middle bear, but with an aperture of f4, the teddy bears in the foreground and background are blurred.

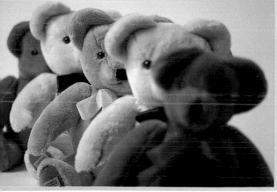

LARGE APERTURE

25 ACHIEVING THE RIGHT EXPOSURE

Most modern cameras have some form of meter to measure light and indicate the appropriate settings to produce correctly exposed film. A well-exposed shot should appear well balanced, with good depth of colour. Most of the detail should appear in the main subject. If a film is underexposed, the print or slide will appear too dark; overexposed film gives results that are too pale.

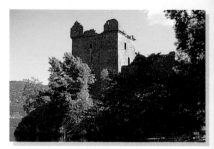

CORRECT EXPOSURE △
Correctly exposed film gives a print with some detail in both light and dark areas. The highlights are bright but not bleached.

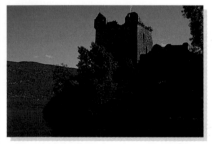

UNDEREXPOSED △
When film is exposed to an insufficient amount of light, the print will be dark and only brightly lit areas will show detail.

OVEREXPOSED △
When film is exposed to too much light, detail appears in areas that were actually in shadow and bright areas are bleached.

26 WHEN TO BRACKET EXPOSURES

When uncertain lighting makes finding the correct exposure difficult, it is advisable to "bracket" exposure. First, take one shot at the settings suggested by your camera's meter, then use the manual controls to override the meter and take extra shots at settings indicating slight under- and over-exposure (this is usually one f-stop up and down).
- Bracket by adjusting either the shutter speed or the aperture size.
- Although bracketing your shots greatly improves your chances of getting good results, it can work out to be rather expensive in film.

27 PROBLEMS WITH EXPOSURE

Under certain conditions your camera's meter might be "deceived" into indicating an incorrect exposure. This problem is particularly evident when the main subject is relatively small in comparison to the surroundings that are also included in the frame, or when the available light is harsh or "contrasty". In such situations you can increase your chances of obtaining a satisfactory result by bracketing exposure. Alternatively, reframing your subject may be a simple but effective remedy *(see the examples below)*.

SHOOTING AGAINST LIGHT △
Here, the camera has set the exposure for the view seen through the window and, consequently, the figures appear in silhouette.

◁ TOO MUCH SKY
In this image the camera has set exposure for the expanse of sky dominating the composition. The castle, which was intended as the main subject, is too dark.

ALTERING THE ▷
COMPOSITION
Correct exposure has been achieved by changing the composition of the image to include less sky. The meter was able to take a reading from the area that was intended as the main subject of the photograph.

28 MANUAL EXPOSURE

The "correctly" exposed photograph is not necessarily always the most effective. Experiment by overriding your camera's meter. Slight under-exposure may result in loss of detail in shadows, but the depth of colour may actually improve. Over-exposure can also be used to enhance a photograph (notably in portraits, where paling the image can help to hide skin blemishes).

CAPTURE A MOOD ▽
If this picture had been exposed "correctly", much of the detail would have been lost from the sky and the mood ruined.

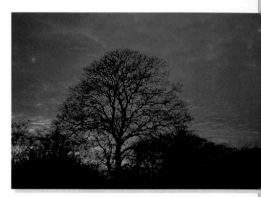

A SENSE OF SOLITUDE ▽
This picture is overexposed so that very little detail is visible in the light background. The effect is to increase the feeling of isolation and tranquillity.

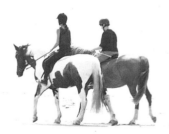

WHICH LENS?

29 UNDERSTANDING FOCAL LENGTH

As the focal length of a camera lens increases, the most obvious effect is that the subject appears larger in the frame. But note also that the angle of view decreases and the detail in the background of an image loses its sharpness as focal length increases.

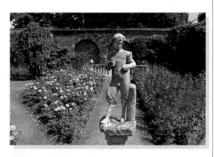

△ WIDE ANGLE
Use a lens with a short focal length to produce a wide angle of view that includes a great deal of background detail in sharp focus. Here, the statue must compete with the flowers for our attention.

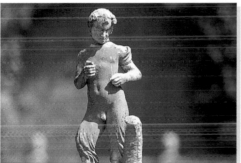

◁ CLOSING IN
By using a lens with a longer focal length, you can isolate the statue so that it commands the viewer's complete attention. Notice how the increase in focal length compresses perspective so that the statue is framed by an arch that was barely noticeable at the short focal length.

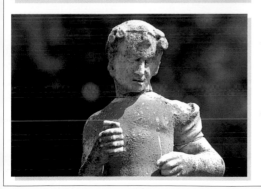

◁ TELEPHOTO LENS
Increase the focal length still further and all background detail is lost and we can clearly see the statue's weathered features. The subject is now magnified so that the frame can accommodate only the head and torso of the satyr.

30 STANDARD LENS

A 50 mm lens is the "normal", or standard, lens with a 35 mm unit, because it shows the subject in a way that is similar to the image seen by the naked eye. For this reason the standard lens is a good choice for general purpose photography, but it is particularly suitable for still-life subjects. Standard lenses are available with wide maximum apertures, allowing them to perform well in low light.

50 MM

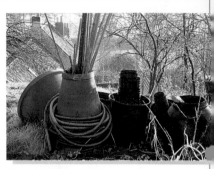

STILL LIFE WITH FLOWERPOTS
This still-life image was shot with a 50 mm lens so that it appears in print very much as it would appear to the average human eye.

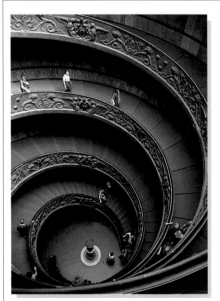

DRAMATIC INTERIOR
Wide-angle lenses are useful for capturing expansive views of building interiors.

31 WIDE-ANGLE LENS

As the focal length of a lens is shortened, so the angle of view that is encompassed gradually increases. At a focal length of 35 mm, the effect of wide-angle distortion is evident. It becomes extreme below 24 mm. A wide-angle lens includes more of the subject than can be viewed by a standard lens at the same distance.

■ Use a wide-angle lens to capture all subjects, both near and far, in sharp focus. This facility makes wide-angle lenses popular with the majority of landscape photographers.

■ Wide-angle lenses exaggerate the comparative size of subjects placed close to the camera in relation to those placed farther away, a trait that can be used to produce some dramatic shots.

28 MM

32 THE ADVANTAGES OF USING ZOOM

A zoom lens covers a range of focal lengths and can make a subject appear closer without changing the camera position, whereas with a fixed-focal-length lens you must actually move closer to your subject in order to make it appear larger in the frame.

- A zoom lens is practical because it allows you to carry just a single lens instead of two or three.
- Zoom lenses are used on most modern advanced compact cameras.

28–70 MM

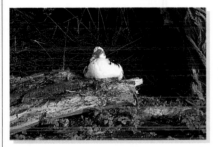

A NERVOUS SUBJECT
This is as close as the photographer dared to venture without distressing the bird.

ZOOMING IN
Using the zoom facility, the photographer can "close in" without changing lenses.

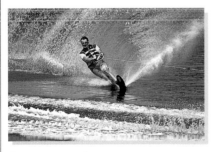

CAPTURING THE ACTION
Sometimes you may want to get close to your subject but are physically unable to (for example, when an expanse of water separates you from your subject). This is when a long lens is a great advantage.

33 LONG LENSES

As the focal length of a lens increases, so the angle of view is narrowed and the image appears magnified in the viewfinder. The effect is clearly noticeable at 85 mm (a good focal length for portraiture) and becomes more dramatic at 100 and 200 mm. Long lenses allow you to take close-ups while keeping your distance, making them especially useful for taking shots of nervous, or even dangerous, animals.

85 MM

CHOOSING FILM

34 HOW TO SELECT THE RIGHT FILM

To a large degree, choosing a type of film is a matter of personal preference. But some films are better than others for certain subject and light conditions, and the best way to learn the differences is to try out the options for yourself.

- You can try prints in colour and in black-and-white, or you might well prefer the brilliance of colour slides.
- Films vary in their sensitivity to light, and there is also some variation between different brands of the same type of film – you must experiment.

35 COLOUR NEGATIVE

Colour negative film is made into prints by projecting a beam of light through the negative onto light-sensitive paper, so minor exposure errors can still be corrected during printing. A poor print may be the fault of the processor. If in doubt, check the quality of the negative.

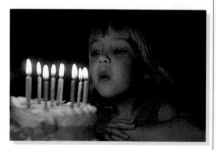

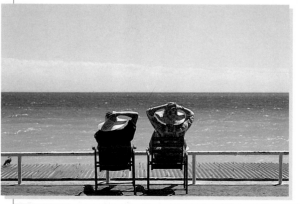

△ FAST FILM
Fast film, with a rating of ISO 400 and above, is very sensitive to light and can be used for taking photographs in dim light conditions when you do not want to use flash.

◁ SLOW FILM
Slow film, ISO 100 and below, offers high-quality images that enlarge well. Ideal for hand-held photos in bright conditions; in dim light, you will need a tripod.

36 SLIDES

Slides are processed without a negative stage and are less tolerant to exposure errors than colour negative film, so it is far more noticeable if you under- or overexpose slides. However, well-exposed slides, viewed by light transmitted from a slide projector or hand viewer, have rich, bright colours.

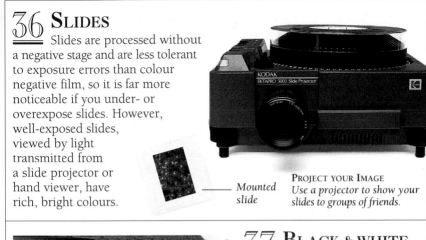

—— Mounted slide

PROJECT YOUR IMAGE
Use a projector to show your slides to groups of friends.

EMPHASIZING SHAPE & TEXTURE
Black-and-white film emphasizes the striking shapes and textures captured in this photograph.

37 BLACK & WHITE NEGATIVE

Black-and-white negative film is less popular than colour film but can be used to create images that send messages clearly and directly. Without the distraction of colour, black-and-white film emphasizes texture, shape, and composition. If you are interested in the process of printing, equipment for black-and-white processing is relatively inexpensive and simple to use.

38 HOW TO LOOK AFTER YOUR FILM

Film must be treated with care if you are to achieve good results:
- Always keep your film (exposed or unexposed) in its plastic container. Otherwise, light will seep in. Also, dirt may collect in the felt light-trap and scratch your entire roll of film.

- Always store film in a cool place; high temperatures can adversely affect the film colour and contrast.
- Process the roll of film as soon as possible after it has been exposed.
- Use your film before it reaches the expiry date indicated on the box.

COMPOSING YOUR PICTURE

39 WHAT MAKES A GOOD PICTURE?

To spot good photographic subjects you must start by learning to take a fresh look at the things around you. You will certainly not have to look far to find a good subject, but you will have to become aware of shape, form, colour, and light, all of which combine to make interesting images.

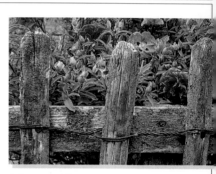

△ BEGIN AT HOME
You should not have to travel further than your own garden to find suitable subjects.

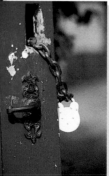

◁ COLOUR
Take a second look at objects that other people would take for granted. This simple image of a weathered gate with a lock and chain is effective because the bright yellow of the lock is a colour that is complementary to the expanse of blue.

◁ CANDID PHOTOGRAPHY
Portraits make powerful and direct subjects that elicit immediate emotional responses.

40 WHICH FORMAT?

A common mistake made by beginners to photography is to assume that the camera should always be held horizontally because it is designed to be more comfortable that way. Use a vertical format if it complements your subject's shape.

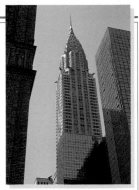

△ VERTICAL FORMAT
The imposing height of this skyscraper is emphasized by adopting a vertical format.

◁ HORIZONTAL FORMAT
The horizontal format is a natural choice when taking photographs of landscapes.

41 FILLING THE FRAME

A simple way to improve the impact of an image is to get closer to your subject so that it fills the frame. It prevents the subject from becoming lost against ugly or distracting background detail.

■ If it is not possible to move closer to your subject, use a telephoto lens to make it fill the frame.

■ Include surrounding shapes or details if they complement or enhance your chosen subject.

△ A DOMINANT SKY
Here, the expanse of sky and horizon prevents the main subject from achieving its fullest dramatic impact.

◁ BEAST OF BURDEN
With the subject filling the frame, the viewer feels the full impact of the disparity of size between the mule and its enormous burden.

42 WHERE TO PLACE THE SUBJECT

Where a subject is placed in the camera frame helps to determine its importance in the composition. But don't feel that your main subject always has to be right in the centre – the effect of this can be rather dull.

Composition is usually improved by placing the main subject off-centre.
▪ You may have to focus manually or use the autofocus lock when you position your subject off-centre in the frame (*see p.20*).

THE RULE OF THIRDS
Imagine that your picture area is divided horizontally and vertically into thirds by two equidistant lines, as is shown here. Each line forms a good location for important structural elements in the composition, and any of the points where two of the lines intersect (four positions in total) would be a suitable position for your picture's main centre of interest.

43 USING THE FOREGROUND

Choose your viewpoint carefully to include strong foreground detail, which gives your image a sense of depth and distance. You may be able to use complementary foreground details to fill the frame if your main subject is small.
▪ Emphasize foreground detail by raising your viewpoint and angling the camera downwards.

SMALL SUBJECT ▷
This image lacks interest when the subject is placed in an empty landscape.

FOREGROUND INTEREST△
Here, a break in the foliage adds foreground interest and frames the subject.

44 MOVING AROUND YOUR SUBJECT

Even very small shifts of viewpoint can make a dramatic impact on a picture's composition. So when you have found a subject to photograph, take the time to move around it and note how the adoption of different viewpoints can transform the scene before deciding where to shoot from.

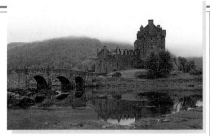

REFLECTIONS IN WATER
From this viewpoint, reflections in the water complete circles under the bridge arches.

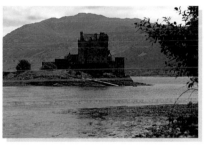

SHOOTING AGAINST THE LIGHT
Here, the main subject appears almost as a silhouette, emphasizing its strong shape.

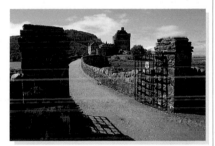

LEADING THE EYE
Here, the pillars create strong foreground interest. The drive leads the eye into depth.

45 HIGH OR LOW VIEWPOINT?

If you are unable to walk around your subject you can still dramatically affect your composition by simply crouching down to try a low viewpoint, which can add dynamism to your composition. By choosing a low viewpoint, you may be able to frame a subject against the sky and exclude an ugly background. Use a higher viewpoint to give a totally different perspective, excluding the sky and giving the main emphasis to the foreground detail.

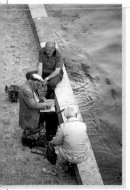

HIGH VIEWPOINT △
LOW VIEWPOINT ▷

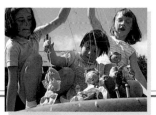

46 USING FRAMES WITHIN FRAMES

Create well-balanced and striking compositions by framing your subject within the confines of an architectural detail, such as a doorway or a window. Such frames often serve to simplify an otherwise distracting background. With a little imagination, suitable framing devices can be found almost anywhere.

- Trees and other forms of vegetation can often serve as highly effective and colourful frames for your subject.
- Use the brim of a hat as a simple but very effective frame for a subject's face.
- Frames don't always have to be hard-edged structures in the foreground; subtle background framing may be more appropriate for certain subjects.

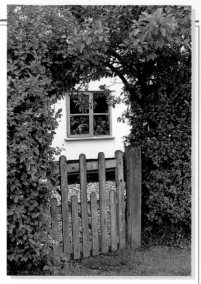

A WINDOW FRAMED
Foliage forms a rich canopy, leading the viewer's eye towards the cottage window.

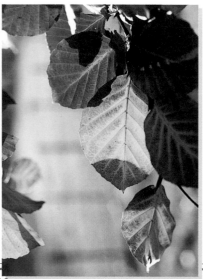

47 EMPHASIZING YOUR SUBJECT

Focus sharply on your main subject to emphasize its importance in your composition. By using a long lens and selecting a wide aperture, it is possible to transform an ugly and inappropriate, or simply distracting, background into an attractive and unobtrusive wash of colour that could greatly simplify and enhance the composition of a photograph.

FOCUSING ON FOLIAGE
Using a close-up lens and restricted focus emphasizes the beauty of autumn leaves. Sharp focusing and strong backlighting reveals the leaves' translucency.

48 INTRODUCING A SENSE OF SCALE

If you are prompted to photograph a subject because of its imposing stature, you may well find that you are disappointed with the results. Much of the subject's impact on the naked eye will be lost on film. To help combat this problem, include a human figure in the frame so that the comparative size of your main subject can be gauged against it.

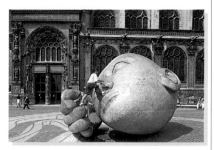

SCALING A LARGE STATUE
By including children, an element of humour is introduced as well as a sense of scale.

49 HOW TO USE LINE

Use linear perspective (the apparent convergence of receding lines) to give your images a strong sense of depth. Similarly, objects placed one behind the other will appear to become smaller, also creating the illusion of depth.

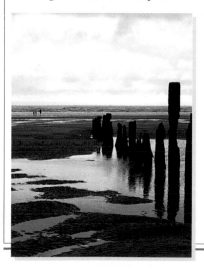

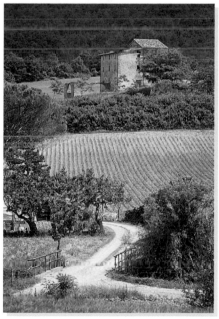

◁ LEADING THE EYE
A row of posts leads the eye into depth.

△ A WINDING PATH
Here, we are led by the path and the lined field.

USING COLOUR

50 COLOUR FOR EMPHASIS

Use colour to dictate the main areas of interest within your composition. A small and otherwise insignificant part of a scene can be dominant if its colour contrasts dramatically with the colour of its surroundings.

■ Some hues seem to seek attention more than others. Red, for example, tends to come forward or "expand". Blues, by contrast, tend to recede.

■ Colour contrasts can be created by the juxtaposition of primary colours (red, yellow, or blue) in a picture.

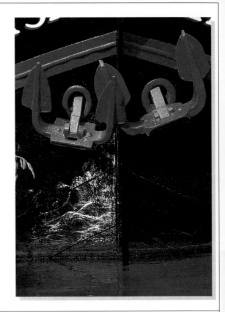

DOMINANT RED DETAIL ▷
Here, vibrant red anchors are dramatically emphasized against the boat's black bow.

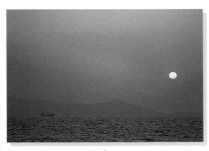

AERIAL PERSPECTIVE △
Here, the ship on the horizon helps to draw the eye into the pale tones of the distance.

51 A SENSE OF SPACE

Objects appear progressively paler and less contrasty the further away they are situated from the camera position. This phenomenon is known as aerial perspective and it can be exploited to add a powerful sense of depth to your composition.

■ Emphasize aerial perspective by including a dark-toned object in the foreground of your composition, but set exposure for the background.

52 COLOUR & MOOD

Use colour to influence the mood of your composition. Rich, saturated colours are intense and lively, whereas paler colours can be used to impart a feeling of calm. We associate orange and yellow with warmth, whereas blues and greens are considered to be cold colours.

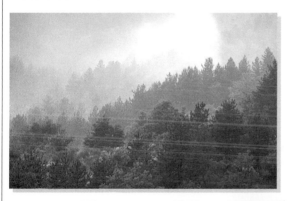

△ BOLD COLOURS
Here, vibrant yellow and blue contrast to produce a lively effect that suits the mood of the carnival scene.

◁ MUTED COLOURS
Pale greens and blues are muted by mist, producing an atmosphere of calm.

COLD COLOURS △
Despite the exotic vegetation, the scene still appears rather cold because it is composed of shades of blue and green.

WARM COLOURS ▷
Bright sunshine makes the warm orange and yellow shades seem richer. Shadows emphasize the general glow.

PATTERN & SHAPE

53 SYMMETRY

Look for symmetry in your subject in order to create a balanced composition; the ordered harmony of a symmetrical pattern is naturally satisfying to the eye. An unusual viewpoint (the camera was placed directly beneath an electric pylon) and careful framing helped to create this strong graphic image (*see right*).

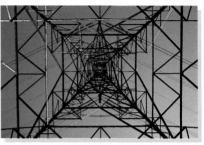

SYMMETRICAL IMAGE

BROKEN RHYTHM

54 BREAKING THE RHYTHM

A pattern that is too formal or rigid can be rather monotonous. In this photograph (*see left*), the rhythmic pattern created by viewing a group of flowerpots from directly above is at once emphasized and relieved by the inclusion of the irregular, sprawling form of a neglected plant.

55 USING SHADOW

The interest in this intriguing photograph (*see right*) is created by the striped pattern of the shadows falling on the rather odd-looking vehicle. The shadows were created by strong sunlight passing through gaps in an old slatted roof. The close viewpoint excludes distracting details.

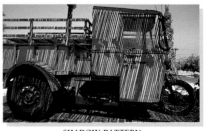

SHADOW PATTERN

56 SHAPE

Looking at shape is usually the first way in which we identify an object and it is therefore an important element in most compositions. In this image *(see right)*, the shape of the fruit is emphasized by the close viewpoint and the contrasting texture of the mass of surrounding leaves.
- Use powerful backlighting to make your main subject appear in silhouette, effectively eliminating all compositional elements other than the object's shape *(see p.44)*.
- If your subject contains more than one strong shape, be sure to position yourself so that they do not clash.

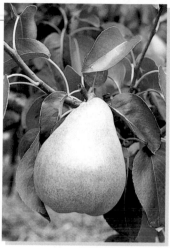

SIMPLE SHAPE

RANDOM PATTERN

57 NATURAL PATTERN

Use close framing to reveal the natural patterns that can be found almost anywhere in nature. In this image *(see left)*, the careful framing and the high viewpoint combine to emphasize a strong natural pattern.
- Taking a close-up photograph of a small section of a pattern can often produce a more powerful image.

58 TEXTURE

Use texture to convey a sense of the surface qualities of a subject. In this picture of an old, weathered roof *(see right)*, it is easy to imagine the rough texture of the tiles.
- The soft, directional lighting of early morning or the evening is ideal for emphasizing a subject's texture.

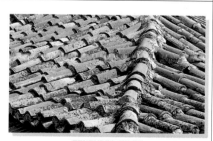

TEXTURED TILES

USING NATURAL LIGHT

59 LIGHT AT VARIOUS TIMES OF THE DAY

Throughout the course of the day, light is constantly changing, and the same subject can appear remarkably altered if it is photographed in the early morning and again at midday. In the early morning, shadows are long as the sun sits low in the sky, and photographs taken at this time have a feeling of depth that is hard to achieve at midday, when the light is much flatter. In the late afternoon the sun begins its descent, and once again the shadows lengthen.

EARLY MORNING

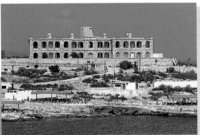

MIDDAY

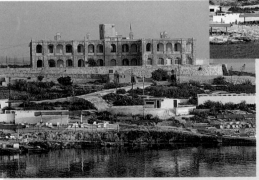

EVENING

CHANGING COLOURS
It is not just the direction of the light that changes as the day advances, the colour of light also changes. As the sun rises and sets, light can have a warm orange hue.

60 HARD & SOFT LIGHTING

Be alert to the effects of the changing quality of daylight. Strong sunlight from a clear sky produces hard, dramatic shadows with bright, contrasting highlights. If a passing cloud were to obscure the sunshine, the effect would be very different. The resulting diffused light would be far more even – with soft shadows and more subtle highlights.

HARD LIGHTING

SOFT LIGHTING

61 HOW TO ADVANCE THE SUNSET

If you have time to enjoy the spectacle of the dramatic light at sunset, take advantage of the opportunity to take outstanding photographs. However, a sunset can be advanced so that it appears to pass through its natural stages by reducing exposure time.

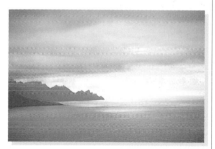

△ SUNSET: "CORRECTLY" EXPOSED
With an exposure of ⅕ at f11 the sunset appears relatively bland and uninspiring. There is very little detail in lighter clouds and the lighting appears hazy and diffused.

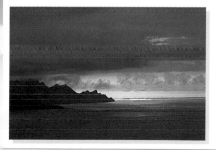

◁ SUNSET: UNDEREXPOSED
Reduce the exposure to ½₅₀ at f11 and the result is much more dramatic. The mood of the scene is more sombre, with greater detail in the clouds. The highlights are far richer.

62 HOW TO MAKE THE SUN MOVE

You may have to wait hours for the sun to move into a suitable position to get an effective shot of a stationary object, such as a statue. However, with a movable object you can have sunlight shining from any direction simply by rotating your subject to the appropriate angle.

- By moving your subject you will also be changing the background, so always remember to check your frame before taking each photograph.
- Remember that the strength of the sunshine will affect the depth of any shadows. Strong sunlight will create high contrast, giving deep shadows.

LIGHT FROM RIGHT

SIDELIGHT FROM LEFT

FRONTAL LIGHTING

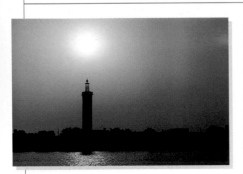

A BACKLIT HORIZON
A hazy sun sends the tall structure directly below into a simple but dramatic silhouette.

63 SHOOT AGAINST THE LIGHT

Shooting backlit scenes emphasizes and simplifies shape, suppressing colour while heightening contrast.

- Produce dramatic silhouettes by setting exposure for the background.
- Exposing for the shadows will give some detail in your main subject and bleach out much of the background.
- Be careful not to damage your eyes when including the sun in a shot, especially when using a long lens.

64 HOW TO AVOID FLARE

Shooting towards the sun can cause flare – scattered light resulting from reflections within the lens itself. Help resolve the problem by fitting a lens hood; otherwise, shade the lens with your hand or shift your viewpoint. Always protect your lenses from dirt; flare is more likely to occur if you are using an old or dirty lens.

Shade the lens with your hand

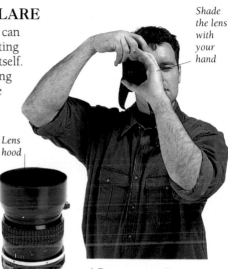

Lens hood

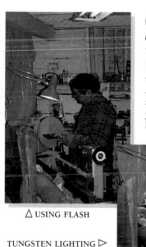

PHOTOGRAPH RUINED BY FLARE

LENS WITH HOOD

△ BLOCKING THE LIGHT
Make sure you keep your fingers out of the frame.

65 LIGHTING CASTS

If your photos return from the processor with an overall orange cast, you have probably been using daylight-balanced film for indoor tungsten lighting. Using your flash can solve the problem. However, if you wish to avoid the harsh lighting sometimes produced by flash, try using a blue filter for tungsten lighting. Other casts may be caused by light reflected from vividly coloured walls, so try to avoid using such surroundings. Errors at the processing stage can also cause colour casts to appear.

△ USING FLASH

TUNGSTEN LIGHTING ▷

USING FLASH

66 AVOIDING RED EYE

Red eye is a major problem that occurs when a built-in flash unit is positioned close to the camera lens. It is caused by light reflecting back off the (red) retina at the back of the eye. The problem is especially common with poorly designed compact cameras, but it is not confined solely to compacts. You can prevent the problem occurring by using an off-camera flash that is positioned away from the lens. Some cameras fire a pre-flash light, causing the iris to become smaller and so reducing the chances of red eye. If your camera does not have this facility, you can achieve the same result by asking your sitter to look at a light before you take the picture.

UNNATURAL EYE COLOUR

67 FLASH FALL-OFF

Light from a flash unit falls off sharply, so that when a shot of a group of people is poorly set up, those nearest to the camera are bleached out, while those furthest away from the camera are too dark. Prevent the problem by setting up the shot carefully in the first place. Before taking the picture, try to arrange the group so that everyone in the shot is positioned at approximately the same distance from the camera.

△ FALL-OFF EVIDENT
Notice how the table and the faces become darker further away from the lens.

◁ EVEN LIGHTING
Change your viewpoint so that the subjects are more evenly situated.

68 USING FILL-IN FLASH

Flash should not be reserved exclusively for night-time shots. Use your flash to reveal detail in shadowed areas of your subject when lighting conditions produce high contrast (often outdoors on bright, sunny days).

WITH FILL-IN

WITHOUT FILL-IN

69 BOUNCED FLASH

BOUNCED TOPLIGHTING

If your off-camera flash unit has a movable head, angle it so that it bounces the light from a white ceiling in order to give a natural-looking, diffused toplit effect. Similarly, angling the flash so that the light is reflected from a nearby white wall will also produce a natural-looking, diffused sidelight. Bounced flash looks natural because the effect is similar to that produced by soft daylight.
■ You do not have to adjust the exposure settings when using bounced flash. Only the head of the flash swivels and tilts, the main unit still measures exposure directly from the subject.

70 ANGLED FLASH

An off-camera flash can be held at arm's length by using a sync lead. This angled lighting gives a more dramatic effect than flash from the camera, but use a side wall to reflect some light back into the shadowed side of your subject.
■ Hold the flash unit at arm's length and angle it at approximately 45° to your chosen subject.
■ Avoid holding the unit too high in relation to the subject. Hold the flash level with your head.
■ If no side wall is available, position a white card near to the shadowed side (but out of the frame).

SIDE LIGHTING

PHOTOGRAPHING PEOPLE

71 AVOID SQUINTING

When photographing people, you must remain alert to changes in expression. If your subject is placed directly facing the sun, he or she will be forced to squint at the lens, giving an uncomfortable and unflattering expression. Wait for a cloud to pass in front of the sun, or else move your subject into a shaded area.

SUBJECT SQUINTING

72 AVOID CLUTTER

Distracting clutter in your frame will take the viewer's attention away from the sitters. Take the time to clear away inappropriate objects, and always keep the photograph setting as simple as possible.

△ **CLUTTERED SCENE**
Here, the sitters are lost among a jungle of objects, which serve only to distract the viewer. Using a flash has thrown shadows, adding to the general confusion of the scene.

◁ **PLAIN SET**
By simply taking the time to clear away the messy coffee table and adjusting a few cushions, the composition of this photograph has been greatly simplified.

73 HOW TO PUT YOUR SUBJECT AT EASE

It is crucial to take the time to relax your subjects and make them feel comfortable about sitting for you. Their discomfort will be all too evident in the final print.
- Use a toy to distract young children.
- Give adults time to prepare, so that they are happy with their appearance.

DON'T SAY "CHEESE"
Asking your subject to say "cheese" is rarely effective. Make the effort to amuse your sitter more naturally.

FALSE SMILE ▷
Telling a child to smile will often produce an obviously false expression.

74 FINDING THE BEST ANGLE

Before taking a portrait, study your sitter from different viewpoints to find the best angles. Even a small change in viewpoint can make a big difference to someone's appearance.

- Square-on gives a rounded look.
- A three-quarter view tends to thin the face and is often a flattering angle.
- A low viewpoint draws attention to the nostrils and looks less natural.

SQUARE-ON VIEW

THREE-QUARTER VIEW

LOW VIEWPOINT

75 AVOID CREATING FALSE ATTACHMENTS

Always study the background detail carefully when photographing people, to check that no obtrusive object is likely to become attached to your subject. For example, you may fail to notice a basket of flowers in the background, but on a two-dimensional photograph it might appear to be perched squarely on your subject's head. This problem, which is known as false attachment, may not be evident to the naked eye. It is sometimes exploited for a humorous effect, but is usually best avoided by changing your position to recompose the photograph. Alternatively, use a wide aperture to blur all of the background detail.

FALSE ATTACHMENT

76 PEOPLE WEARING GLASSES

Always focus carefully on your subject's eyes in portraiture – they are the most expressive feature. But pay special attention when shooting people wearing spectacles. If you are using built-in flash, the light may appear as a conspicuous reflection in the glasses. Ask your sitter to remove the spectacles or, if this causes discomfort, try tilting his or her head slightly downwards, to reflect the light away from your camera lens.

▷ **HEAD TILTED**
By tilting the head slightly, reflections are avoided. But be sure that the tops of the frames do not block the eyes.

△ **SPECTACLE REFLECTION**
With your subject facing directly into the camera, the lenses will show the bright reflection of built-in flash.

77 USING THE RIGHT LENS FOR PORTRAITS

As a rule of thumb, it is usually best to move in close enough to fit the head and shoulders into the frame. But if your camera is fitted with a standard or a wide-angle lens, then moving in too close to your subject will cause highly unflattering distortion that will make the sitter's nose appear too prominent and, in the most extreme instances, the ears will seem to disappear entirely.

■ Ideally, choose an 80–90 mm lens, and remain farther back.
■ With a wide-angle lens, remain farther back, then enlarge from the negative.

LONG LENS

WIDE-ANGLE LENS, USED TOO CLOSE

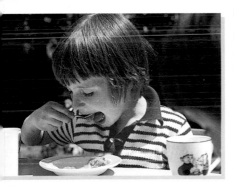

REFLECTED SUNLIGHT
In this photograph, sunlight reflected off the white tablecloth was sufficient to fill in some detail in the child's face, which is in shadow.

78 NATURAL FILL-IN

Deep shadows caused by strong directional light (such as sunlight) can be filled in without applying a second source of light. Simply position a large reflective surface facing the shaded part of the subject to reflect light back.

■ Try using a sheet of white card or silver foil; alternatively, move your subject near to a white wall.
■ A newspaper or a book read by the subject will give some fill-in.
■ Do not use a coloured surface or you will create a cast (*see p.45*).

79 INFORMAL PICTURES OF CHILDREN

Patience, a sense of humour, and plenty of film are your most valuable assets for photographing children. Children make excellent subjects but easily become bored and restless, so try to catch them when they are too occupied at play to be interested in what is happening with the camera.

- Use a hand-held camera and follow movements and expressions through the camera's viewfinder.

- Use a zoom lens for more flexible framing without intruding on their play.
- Babies tire easily and are unpredictable, so always try to work fast and be alert to any changes in expression.
- Use fast film for flexibility with exposure settings.

◁△▽ **CANDID SHOTS**
Children make ideal subjects for candid photography. For best results, use a long lens and fast film.

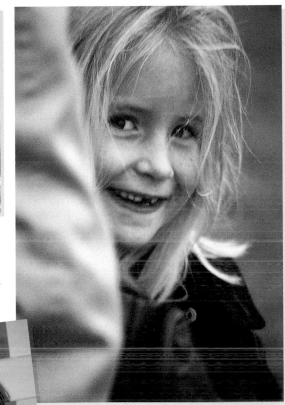

SHY CHILD ▷
By using a long lens and playing a game of hide and seek, the photographer is rewarded for his efforts with a charming smile from a rather reluctant model.

◁ STRAIGHT SHOT
Young children are usually less self-conscious than adults. However, it is a good idea to keep a child amused with constant chatter and to take an interest in the child's response.

LOW VIEWPOINT
Take portraits of children from a low viewpoint with the camera placed at the child's eye level. This will produce a stronger impact, creating immediacy and intimacy. A picture taken from an adult's height may cause distortion.

80 SPECIAL OCCASIONS

Weddings and other special events provide ideal opportunities to take memorable photographs. Formal wedding shots are best left to the professionals, but while the official photographer is busy preparing at the church, take the opportunity to capture candid "behind the scenes" moments of the bride's preparations that will delight family and friends after the event and complement the official photograph album.

MOTHER OF THE BRIDE

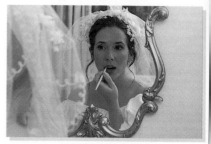

FINISHING TOUCHES

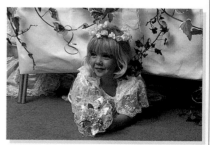

A YOUNG BRIDESMAID

BLACK & WHITE SHOTS △▷
Always take plenty of film for special events. Black-and-white film can be highly effective for outstanding wedding shots.

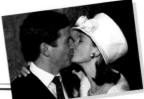

81 SHOOTING PAIRS

When photographing two people, be it a mother and child, or two friends, always try to show some form of interaction between the subjects that helps to suggest their relationship to each other.

- Grandparents and grandchildren make excellent double portraits. Soft, diffused lighting emphasizes the contrasting skin textures.
- If you are using autofocus to take a portrait of a couple standing side by side, be sure you do not accidentally focus between them, or your subjects may well appear blurred on the film (see p.20).

PLAYFUL POSE ▷
Children are usually far more relaxed if asked to pose with a sibling or a friend.

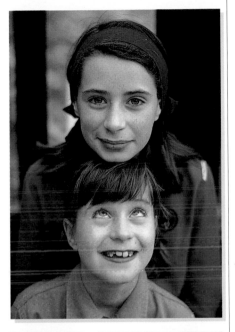

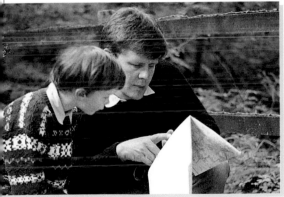

INTERACTION ADDS INTEREST △
The most interesting photographs are often those taken when the subjects are absorbed in some enjoyable activity.

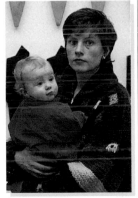

MOTHER & CHILD △
Mothers and their babies are highly photogenic subjects.

82 SELF-PORTRAITS

Include yourself in the frame by using the delayed action timer, which is fitted in most modern cameras. Decide beforehand where you will be standing for the photograph and focus the lens to the appropriate distance.

■ Self-timers usually allow a delay of ten seconds between pressing the shutter release and the shot being taken, giving you ample time to take your position.

■ A long cable release will enable you to take a self-portrait without a self-timer.

■ A simple method of taking your own portrait is to photograph your reflection in a mirror. Hold the camera at waist height to exclude it from the frame.

■ A tripod is required to position the camera at the correct level.

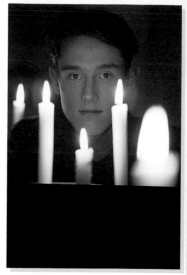

SELF-PORTRAIT BY CANDLELIGHT

83 GROUP SHOTS

Always compose group shots so that the figures obviously relate to each other. Take several shots of any one arrangement to increase the chances of having one shot in which everyone appears at their best. Use soft, diffused lighting, to prevent shadows obscuring any individual.

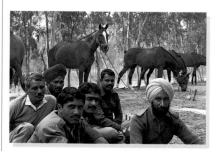

HORSEMEN △
The horses in the background give a clue as to how the group of men in the foreground of the picture relate to each other.

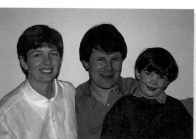

◁ THREESOME
When arranging groups of people, remember that odd numbers tend to be easier to compose satisfactorily than even numbers.

SPECIAL SUBJECTS

84 PHOTOGRAPHING YOUR PETS

When photographing pets, it is a good policy to use an assistant to attract the animal's attention in whichever direction you wish, by either calling its name or offering it a tasty morsel to eat.

■ Photograph your pet when it is absorbed in play. These shots will capture your pet's character.

■ Cats usually have preferred routes through the garden. By prefocusing on a specific point, you may be able to capture a dramatic leap between a fence and a windowsill.

■ When taking close-up shots, check that your pet's eyes and ears are clean beforehand.

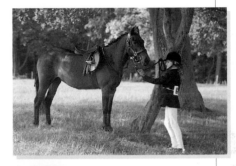

△ PET PONY
Showing pets interrelating with their owners offers an extra dimension of interest to the viewer.

◁ A FAVOURITE TOY
It is a good idea to distract your pet with a favourite toy, which may also provide an area of colour.

◁ CAT SNAP
Cats are creatures of habit. Capture your cat while it naps in its favourite sunny spot in the garden.

EYE LEVEL TIP
Photographs of pets are more interesting if taken from the animal's level. So crouch down for smaller animals, or place them on a convenient table-top.

85 WILDLIFE

A long lens and patience are the photographer's most useful assets when shooting wildlife. The majority of creatures are wary of humans, so use a lens with a long focal length that will enable you to maintain a respectful distance. Those with the most patience are usually rewarded with the most stunning photographs. Part of the pleasure of photographing wildlife is derived from familiarizing yourself with your subject's habits.

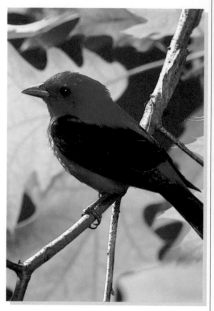

△ PHOTOGRAPHING BIRDS
Picking a contrasting background helps to emphasize the bird's rich colouring.

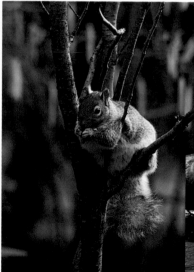

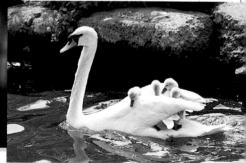

△ TIME TO SHOOT
This squirrel was occupied with his food, providing plenty of time for the photographer to frame the shot.

ANIMALS & THEIR YOUNG △
Some situations present themselves only briefly. Here, a zoom lens with autofocus was helpful.

86 LANDSCAPES

Wide-angle lenses are popular for landscapes as they include more foreground and give sharp focus throughout. To take successful landscapes, you must develop a good eye for the effects of light and weather in all seasons. Mist and haze will give a sense of mystery and subdue colour; bright sunlight will create strong colours.

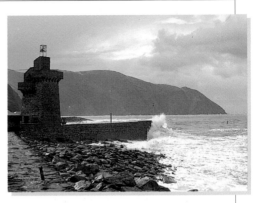

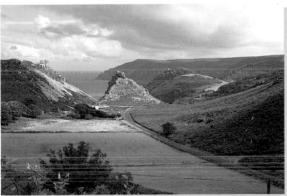

△ DRAMATIC SEASCAPE
Stormy weather brings dramatic light changes. Here, the dramatic mood is heightened by the dark, looming tower and the crashing wave.

◁ FOREGROUND FOCUS
The foreground foliage in this photograph adds to the sense of depth. The road leads the eye into the middle-distance and towards the hazy blue hills beyond.

87 HORIZON TILT TIP

A landscape photograph that is perfect in every other way can be ruined by image tilt. This problem arises when the photographer has neglected to check that the line of the horizon is parallel with the top and bottom of the frame in the viewfinder. Some images can be rectified by cropping at the printing stage.

SLANTING HORIZON

88 HOW TO PHOTOGRAPH PANORAMAS

Panoramic cameras have a specialized lens that rotates to scan an extremely wide field of view. For those who do not wish to specialize in this particular area, similar results can be achieved by simply combining pictures taken with a standard lens.

■ Decide on the features you wish to include in the panorama and take several photos from the same spot.

■ Avoid using wide-angle lenses due to the risk of distortion at the edges.

■ Keep the camera horizontal for every shot; use a tripod if possible.

■ Some cameras offer a Panorama Mode that crops into the centre of the frame, giving a wider-looking image. A similar result could be achieved using a pair of scissors to simply crop into a standard print.

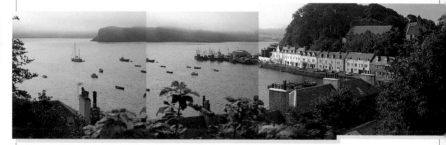

COMPOSITE PANORAMA △
This view is composed of three standard lens pictures. Overlap each print by 30 per cent to create the panorama.

ONE-USE PANORAMA ▽
Some one-use cameras can produce highly effective panoramic photographs without having to take a sequence of shots.

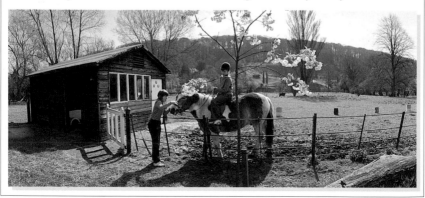

89 BUILDINGS

Buildings, which can be so imposing to the naked eye, are too often disappointing when captured on film. Try experimenting with different viewpoints to restore some of the drama to the printed image and, where possible, return to the site at different times of day to find the most impressive lighting. With a wide-angle lens, the lines of a building can be made to converge dramatically, which can convey a strong sense of depth in a print.

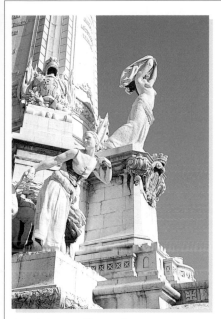

ARCHITECTURAL DETAIL △
Use a telephoto lens to pick out some of the more interesting architectural details that are features of many buildings.

UNUSUAL VIEWPOINT △
A dramatic viewpoint can greatly enhance the composition. Here, the foreground detail frames the skyscraper and adds depth to the photograph.

◁ FINDING PATTERN
The fire escapes on this tenement block create an interesting pattern. The lighting is crucial here; long shadows would reduce the impact.

90 INTERIORS

Photographing interiors involves working within a confined space, so a wide-angle lens is usually required. Another essential item is a tripod. Natural-light levels are often low, requiring slow shutter settings, so support the camera to prevent blur from camera shake. A major problem when shooting interiors is distortion caused by tilting the camera back to include high detail. A special "shift" lens or "perspective control" lens is available to deal with this problem.

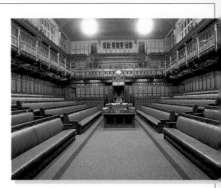

△ THE RIGHT VIEWPOINT
Choosing the right viewpoint is crucial with interiors. This central view is well balanced.

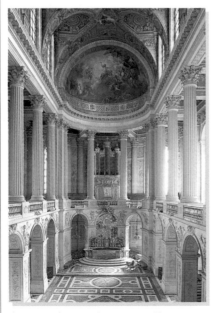

△ HOW TO AVOID CONVERGING VERTICALS
By shooting from a central balcony, the photographer could keep the camera upright.

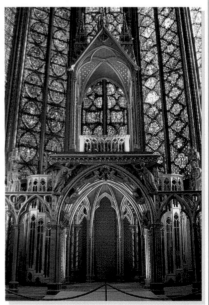

△ CONVERGING VERTICALS
The camera had to be tilted to include the window, resulting in distorted perspective.

91 DRAMATIC SKYLINES

To create a dramatic skyline, keep the horizon low in the frame and expose for the brightest part of the sky. This will emphasize the sky, produce richer colours, and suppress distracting land detail.

- A cloudy sky at sunset or dawn can provide the best opportunity for colourful and dramatic skies.
- Be aware that exposure settings for a cloudy sky can dramatically change in a matter of seconds.
- Use a polarizing filter in order to heighten the contrast between the clouds and the sky without affecting other colours.

△ CHOOSING A HIGH HORIZON LINE
The skyline here is crucial to the mood, but the image is dominated by the foreground detail.

▽ CHOOSING A LOW HORIZON LINE
A low horizon and the vulnerable yachts make the dark, ominous clouds seem more menacing.

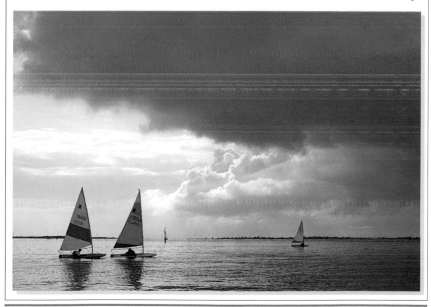

92 NIGHT-TIME PHOTOGRAPHY

Night photography without a flash is now possible with many modern cameras, but the long exposure time required means that it is advisable to use a fast film (ISO 400–1600). Use a tripod to avoid camera shake. Cityscapes, which may be dismal and uninteresting during the day, can make excellent subjects for night photography, transformed by illuminated street lamps, vehicle lights, windows, and shop signs.

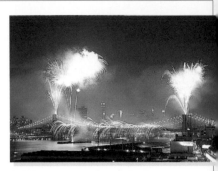

△ **A SPECTACULAR SUBJECT**
Firework displays, such as this one shot over New York's Brooklyn Bridge, can make spectacular night-time subjects.

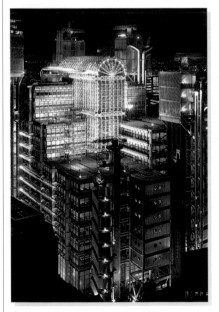

△ **ILLUMINATED BUILDINGS AT NIGHT**
Buildings are transformed at night. Bracket exposures to improve the chance of success.

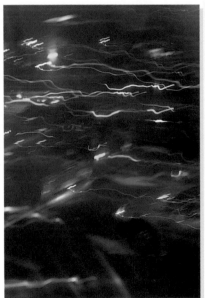

△ **TRAFFIC-LIGHT TRAILS**
Traffic, and a moving hand-held camera, created this effect (4 seconds' exposure).

93 USING REFLECTION

Be alert to the possibilities of exploiting reflections for interesting creative photography. Mirrors, for example, can add instant interest to portraiture. Uninspiring buildings and landscapes can be transformed by simply shifting your viewpoint to include a reflection in a river or lake. Remember to measure exposure for the reflected area if that is what you want to emphasize in your print.

◁ REFLECTIONS IN GLASS
Buildings reflected by the glass walls of other buildings create intriguing images.

▽ MIRROR IMAGES
Reflections on the surface of still water can produce fascinating symmetrical patterns.

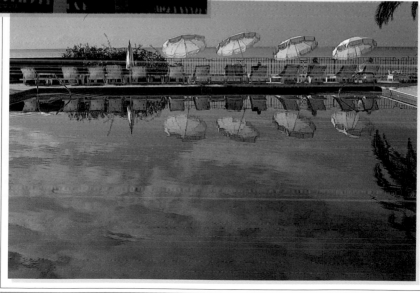

94 ACTION SHOTS

A long-focus zoom lens is an invaluable piece of equipment when taking action shots. It helps you to keep track of the action and to fill the frame from a distance. Use a fast shutter speed to stop action shots from blurring, although sometimes blur can actually heighten the sense of movement and enhance an action photograph. Avoid using flash, as it may distract the competitors.

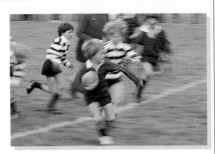

△ BLUR FOR ACTION
A slow shutter speed (⅕ sec.) is used here to capture the movement and thrill of the game.

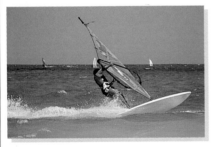

△ TELEPHOTO LENS
A 200 mm lens and a fast shutter speed was required to take this dynamic photograph.

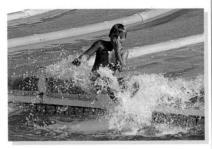

△ FAST SHUTTER SPEED
Here, the dramatic splash at the bottom of a slide is frozen using a ⅟₅₀₀ sec. shutter speed.

95 HOW TO CAPTURE THE RIGHT MOMENT

Choosing the right moment to press the shutter release button can be a matter of split-second timing for a successful sports photograph. Follow the action through the viewfinder, but keep your other eye open to see what is about to enter the frame. A motor drive can be employed to take up to four frames per second.

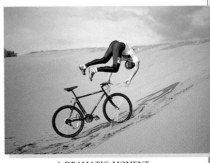

A DRAMATIC MOMENT

96 STILL LIFE

As its name suggests, still-life photography is the art of creating effective compositions of stationary objects. It is an excellent discipline for learning to control lighting and gaining an understanding of design.

- A good eye for detail is critical when photographing still-life subjects.
- Be aware of the mood expressed by your still-life arrangement, and remove any articles conflicting with the overall feel of the composition.
- Use a tripod or a similar support to keep the camera position consistent as you make minor adjustments.
- Looking for "found" still lifes, which may be anything from seashells on a beach to a rusty watering can in the garden, will train your eye to notice pictures you might otherwise miss.

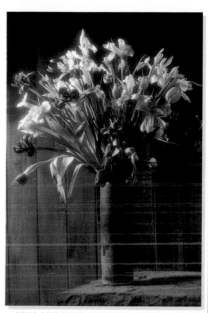

STILL LIFE WITH FLOWERS IN SOFT FOCUS

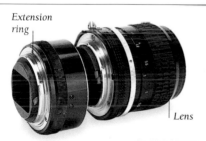

Extension ring

Lens

△ EXTENSION RING
An extension ring is a simple close-up attachment fitting between the lens and the SLR camera body.

97 CLOSE-UP SHOTS

Use a macro lens or a special lens attachment when taking close-up shots. Work with apertures of at least f16, because depth of field will be very shallow. Also, lighting can be tricky because the camera itself will block much of the available light, so it may be necessary to use flash.

◁ LAPIS LAZULI
Close-up photography is useful for people who want to keep a record of collectable items.

PRESENTING PRINTS

98 ALBUMS

Put your favourite prints in an album, where they can be stored safely and conveniently.

- Albums with large pages provide scope for imaginative displays.
- Practical pocket-size albums are available, which house prints in individual plastic sleeves.
- Never store your prints where there are frequent fluctuations in temperature, such as in an attic.
- Do not store prints in damp areas. The images will deteriorate.

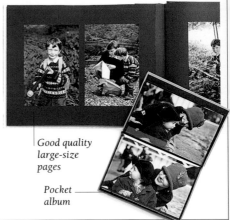

Good quality large-size pages

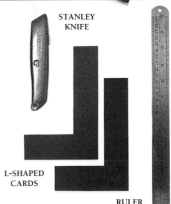

Pocket album

99 CROPPING PRINTS

By cropping a print you may be able to transform an image that was thoughtlessly composed. You could perhaps change the format from horizontal to vertical or vice versa, or opt for a square format that your 35 mm camera would not accommodate.

- Use two L-shaped pieces of plain card to select your favourite crop (*see facing page*).
- Do not use scissors to trim prints as it is difficult to achieve a neat edge. Instead, cut your print with a stanley knife or a scalpel. Use a strong metal ruler as a guide.

STANLEY KNIFE

L-SHAPED CARDS

RULER

100 FRAMING YOUR PRINTS

Keep outstanding prints on permanent display by mounting and framing them to hang in your home or to present as gifts to your friends.

■ Do not hang your prints in direct sunlight. The strong light will eventually cause colours to fade.

■ It is vital to choose an appropriate colour for your mounting card and frame. Buy a selection of cards from your local craft shop and note the effect that the different colours have on your photograph.

■ For best results, purchase special selected-quality glass, because ordinary glass often has flaws that can detract from the appearance of your picture.

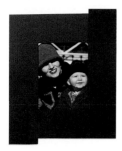

△ THE RIGHT CROP
Use two L-shaped cards to select your preferred crop.

△ COLOURED MOUNTS
*Cut the outer mount 5 mm
(⅛ in) larger than the inner.*

△ SECURING THE PICTURE
*Secure the photo to the inner
mount with masking tape.*

Wooden
frame

101 OTHER PRESENTATION METHODS

Apart from the traditional methods of presenting photographs, many processors now offer to present your favourite images in the form of paperweights, table mats, decorative plates, jigsaws, and keyrings. Modern technological innovations provide interesting alternative storage ideas.

■ Photographs can now be stored on compact disc. Film originals can be digitally transferred onto CD for display on a television screen.

■ If you have a camcorder allowing close-ups, copy a sequence of your best prints onto video tape. Allow about 8 to 12 seconds per picture.

INDEX

A

action shots, 66
aerial perspective, 38
albums, 68
angled flash, 47
animals, 57–8
aperture, 23
autofocusing, 20

B

backgrounds, 21, 50
backlighting, 44
bags, 12
black-and-white negatives, 11, 31
blower brushes, 13
blurred images, 18, 20, 22
bounced flash, 47
bracketing exposure, 24
buildings, 61

C

cable releases, 19, 56
camera shake, 18
cameras:
 care and cleaning, 13
 choosing, 8–10
 holding steady, 18–19
 loading films, 15
 unloading films, 16
 viewfinders, 17
casts, lighting, 45
children, 52–3
clamps, 12, 19
cleaning cameras, 13
close-up shots, 67
clutter, 48

colour, 38–9
 and composition, 32
 filters, 14
 lighting casts, 45
 and mood, 39
 negatives, 11, 30
 slides, 11
compact cameras, 8, 9
composition, 32–7
 colour and, 32, 38–9
 pattern and shape, 40–1
cropping prints, 68

D

daylight, 42–5
daylight filters, 14
depth of field, 23

E

exposure, 24–6
extension rings, 67

F

f-numbers, 23
false attachment, 50
fast films, 30
fill-in flash, 47
film:
 black-and-white, 11, 31
 care of, 31
 choosing, 30
 colour, 11, 30
 fogging, 16
 loading, 15
 slides, 11, 31
 speed, 30
 35 mm format, 11

filters, 14
flare, 45
flash, 14, 46–7
 angled, 47
 bounced, 47
 fall-off, 46
 fill-in, 47
 lighting casts, 45
 red eye, 46
focal length, 27
focus:
 aperture, 23
 autofocusing, 20
 manual focus, 21
fogging, 16
foregrounds, 21, 34
format, 33
frame, filling, 33
frames within frames, 36
framing marks, 17
framing prints, 69
freezing movement, 22

G

group portraits, 56

H

high viewpoint, 35
horizon, tilted, 59
horizontal format, 33

I

interiors, 62

L

landscapes, 59
lens cloths, 13

lens hoods, 45
lenses:
 choosing, 13
 cleaning, 13
 focal length, 27
 for interiors, 62
 long, 13, 29
 macro, 67
 for portraits, 51
 standard, 28
 telephoto, 27, 66
 wide-angle, 13, 27, 28, 59
 zoom, 29, 66
light:
 aperture, 23
 casts, 45
 exposure, 24
 film speed, 30
 flare, 45
 flash, 46–7
 natural light, 42–5
 shooting against, 44
linear perspective, 37
long lenses, 13, 29
low viewpoint, 35

M
macro lenses, 67
monopods, 12, 19
mood, and colour, 39
motor drives, 66
movement, freezing, 22

N
natural light, 42–5
negatives, 11, 30–1
night time, 64

O
one-use cameras, 9
overexposure, 24, 26

P
panoramas, 60
parallax error, 17
pattern, 40–1
people, 48–56
perspective, 37, 38
"perspective control lenses", 62
pets, 57
polarizing filters, 14, 63
portraits, 32, 48–56
 backgrounds, 50
 children, 52–3
 double portraits, 55
 group portraits, 56
 lenses, 51
 self portraits, 56
 prints, 30, 68–9

R
red eye, 46
reflections, 65
rhythm, composition, 40
rule of thirds, 34

S
scale, sense of, 37
self portraits, 56
self-timers, 19, 56
shadows, 40, 42, 44, 51
shapes, composition, 40–1
"shift" lenses, 62
shutter speeds, 18, 22
silhouettes, 41, 44
sky, overexposure, 25
skylines, 63
slide films, 11, 31
slow films, 30
SLR cameras, 10
special occasions, 54
spectacles, 50
squinting, 48

standard lenses, 28
still life, 67
sunsets, 43
supports, 12, 19
symmetry, 40

T
telephoto lenses, 27, 66
texture, 41
tripods, 12
tungsten lighting, 45
tweezers, 13

U
underexposure, 24, 26
UV filters, 14

V
vertical format, 33
viewfinders, 17
viewpoint:
 children, 53
 composition, 34–5
 portraits, 49

W
weddings, 54
wide-angle lenses, 13, 27, 28, 59
wildlife, 58

Z
zoom lenses, 29, 66

Acknowledgments

Dorling Kindersley would like to thank Hilary Bird for compiling the index, Ann Kay for proof-reading, and Janos Marffy for illustrations. Special thanks to Patricia and Grace Moore, Emily Copp, Daniel O'Sullivan, William Thompson, Claire Pegrum, Simon and Jo Cartwright, and Lesley and Andrew Perry for modelling.

Photography
KEY: t *top*; b *bottom*; c *centre*; l *left*; r *right*
All photographs by Michael Langford except;
Max Alexander 2, 37t, 62bl; Akhil Bakhsh 32b, 33bl, br, 52b, 56c; John Bulmer 23, 25c, b, 26b, 27, 29b, 30t, 54t, cr; Philip Gatward 9b, 11bl, c, 13b, 14t, 16l, 18,19, 22tr, tl, 25t, 34br, bl, 39bl, 43c, b, 44tl, c, r, 46bl, br, 47c, b, 48t, 50t, 51tl, r, 52c, 56t, 66cl, cr, 66b, 71; Bob Gordon 7b, 8, 10, 13t, 14b, 17b, 31tr, c; Stephen Hayward 67t; John Heseltine 39tl, tr; Jacqui Hurst 28t, 32t, 36t, 40c, 41t, 57b; Dave King 64t; Neil Lukas 35bl; Ray Moller 57t; Damien Moore 11t, cr, br, 16r, 17t, c, 20, 21, 22br, bl, 29tr, l, 32c, 34t, 37bl, 40t, 44b, 45bl, br, 46t, 48c, b, 49, 50c, b, 53b, 55br, 56b, 58bl, 62br; Steven Oliver 64bl; Vincent Oliver 62t; John Parker 59b; Ian Perry 54cl, b; Spinim Sayer 30b, 37br; Harry Taylor 67b; Ann Thompson 55bl; Matthew Ward 3, 5, 9t, 15, 45c, r, 67c, 68, 68; Steven Wooster 39br.

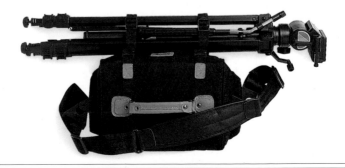